an invitation to
LOVE

an invitation to
LOVE

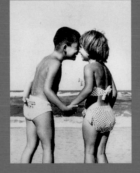

EDITED BY
WYNN WHELDON

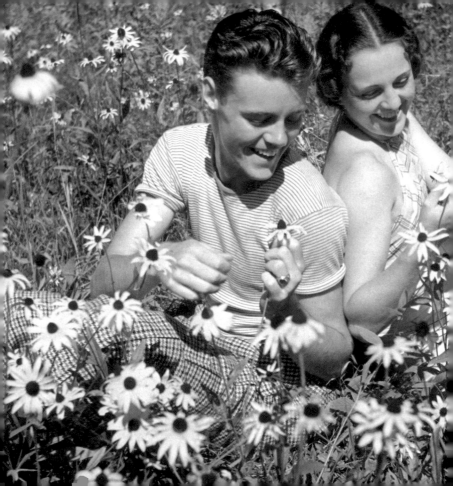

Life is the flower
for which love is
the honey.

Victor Hugo

This is the miracle that
happens every time to
those who really love;
the more they give, the
more they possess.

Rainer Maria Rilke

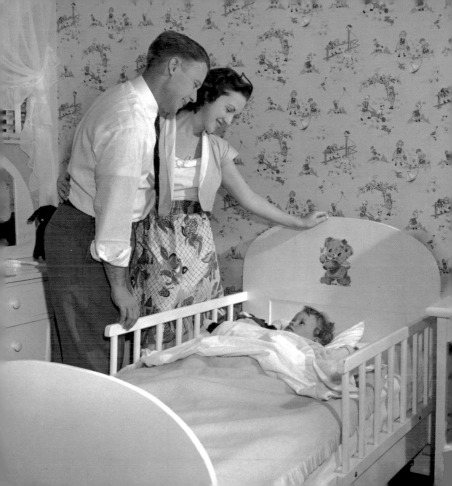

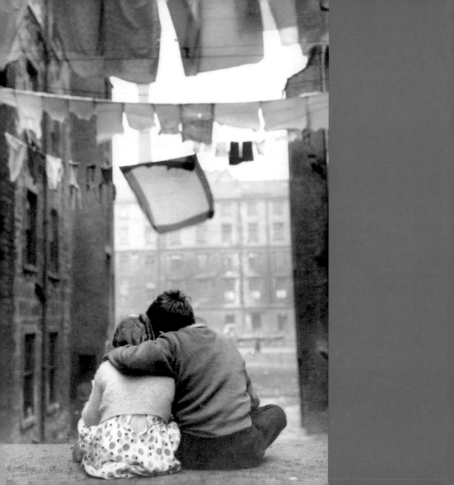

Who, being loved, is poor?

Oscar Wilde

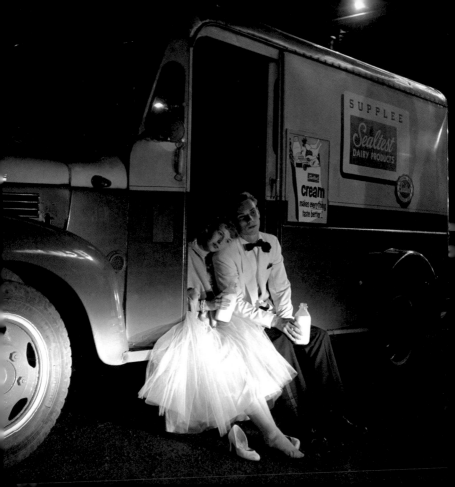

Couples who love
each other tell each
other a thousand
things without talking.

Chinese Proverb

Keep me as the apple
 of the eye,
Hide me under the
 shadow of thy wings.

The Bible, Psalms 17:8

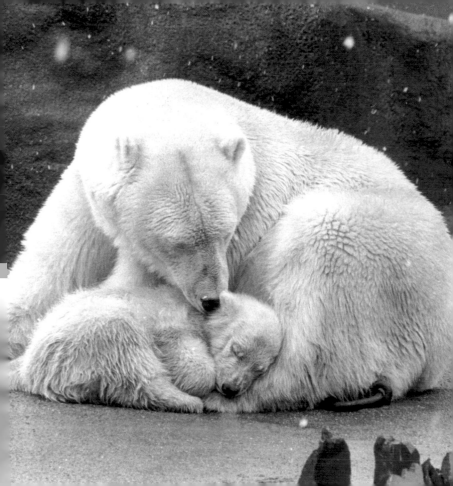

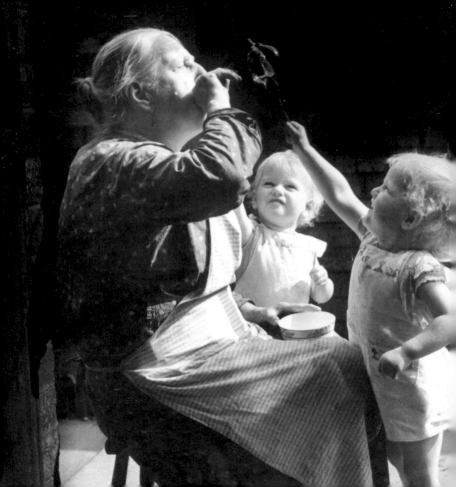

A heart that loves
is always young.

Love does not consist in
gazing at each other, but in
looking outward together in
the same direction.

Antoine de Saint-Exupéry

16

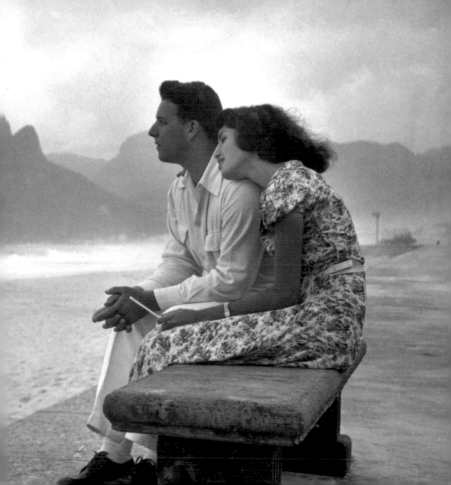

The magic of
first love is our
ignorance that it
can ever end.

Benjamin Disraeli

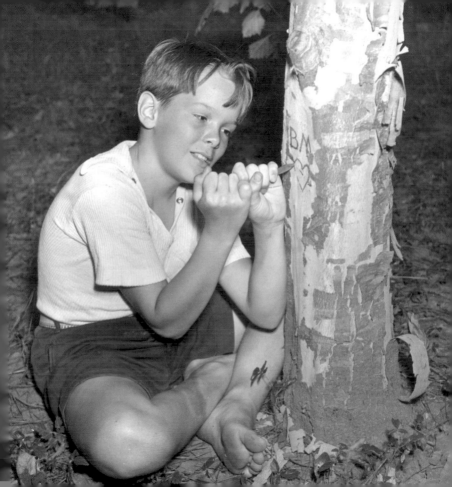

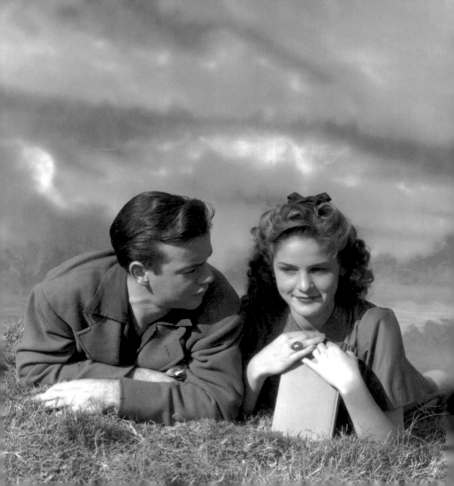

Do you ask what the birds say? The Sparrow, the Dove,
The Linnet and Thrush say, "I love and I love!"
In the winter they're silent—the wind is so strong;
What it says, I don't know, but it sings a loud song,
But green leaves and blossoms, and sunny warm weather
And singing and loving—all come back together.
But the Lark is so brimful of gladness and love,
The green fields below him, the blue sky above,
Then he sings, and he sings; and for ever sings he—
I love my Love, and my Love loves me!"

Samuel Taylor Coleridge

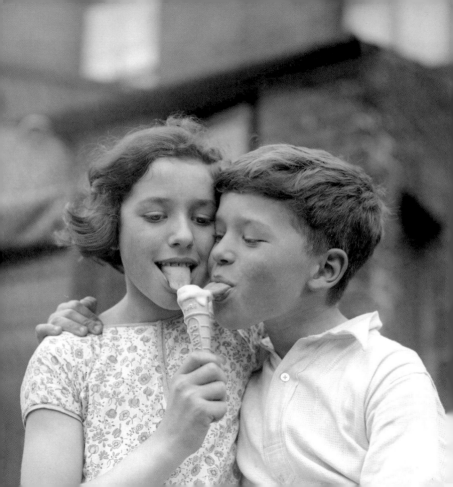

Shared joys
make a friend...

Nietzsche

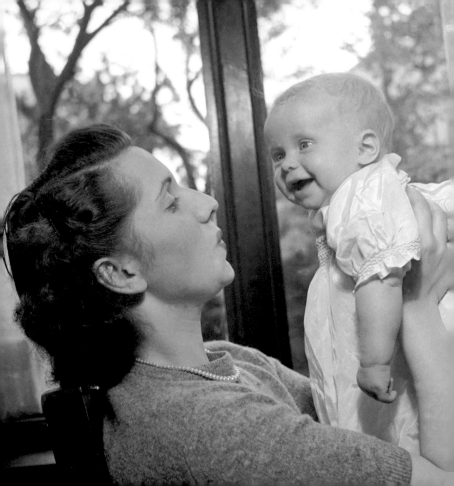

Motherhood: All love begins and ends there.

Robert Browning

Was there such a night, it's a thrill
 I still don't quite believe,
But after you were gone, there was
 still some stardust on my sleeve.

Johnny Mercer

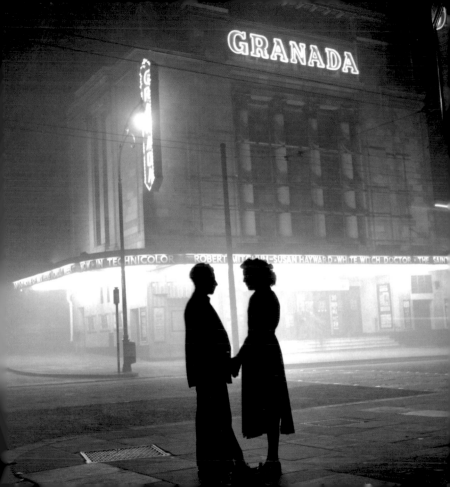

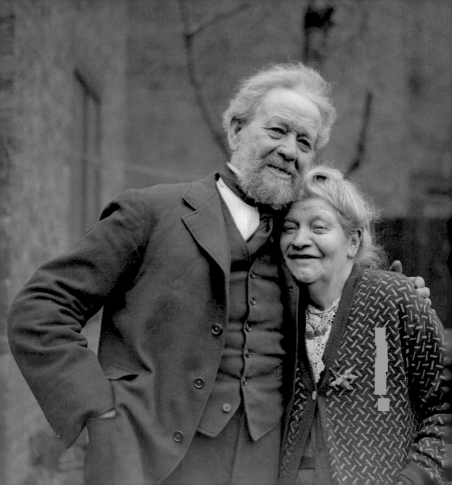

We've been together now for forty
 years,
An' it don't seem a day too much;
There ain't a lady livin' in the land
As I'd swop for my dear old Dutch.

Albert Chevalier

There is no reciprocity.
Men love women,
women love children,
children love hamsters.

Alice Thomas Ellis

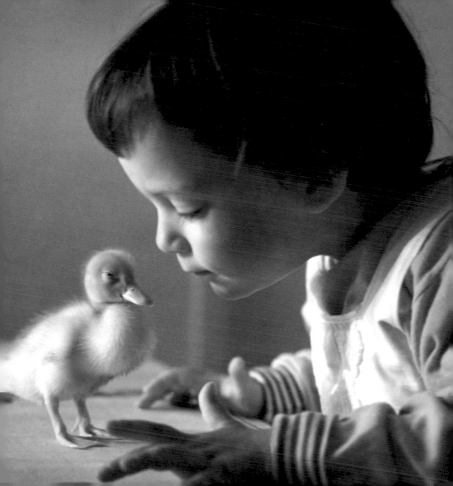

Wild Nights – Wild Nights!
Were I with thee
Wild Nights should be
Our luxury!

Futile – the Winds –
To a Heart in port –
Done with the compass –
Done with the Chart!

Rowing in Eden –
Ah, the Sea!
Might I but moor – Tonight –
In Thee!

Emily Dickinson

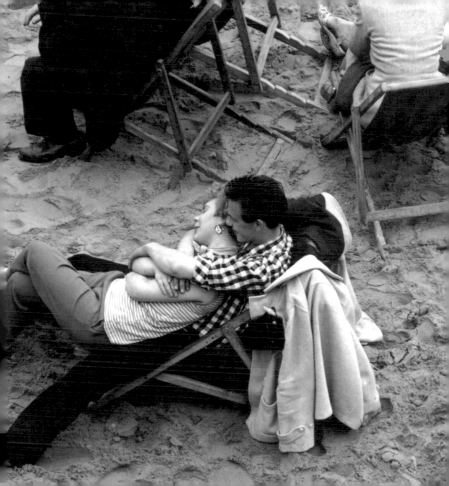

Beware you be not
swallowed up in books!
An ounce of love is worth
a pound of knowledge.

John Wesley

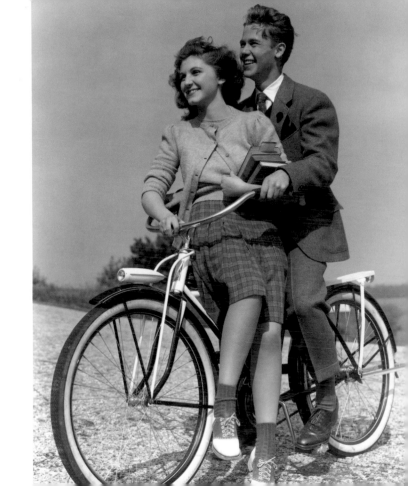

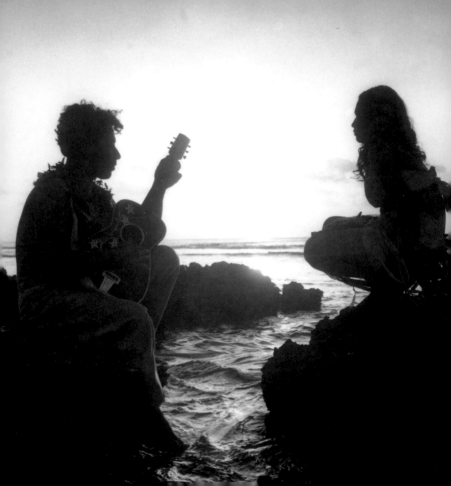

And is it night? Are they
 thine eyes that shine?
Are we alone and here?
 And here alone?
May I come near? May I but
 touch thy shrine?

<div align="right">Anonymous</div>

There is only one pretty child in the world, and every mother has it.

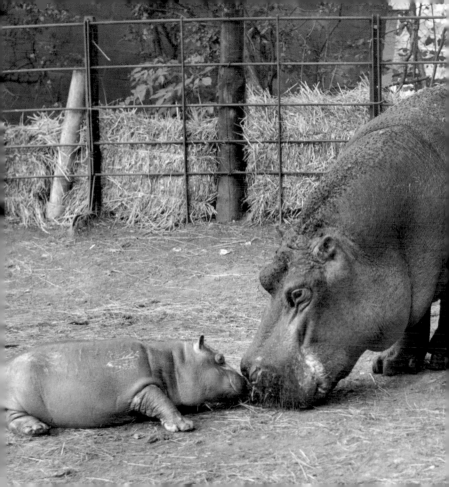

Once upon a time there was a dear little girl who was loved by every one who looked at her, but most of all by her grandmother, and there was nothing that she would not have given to the child. Once she gave her a little cap of red velvet, which suited her so well that she would never wear anything else; so she was always called "Little Red-Cap."

Jacob and Wilhelm Grimm

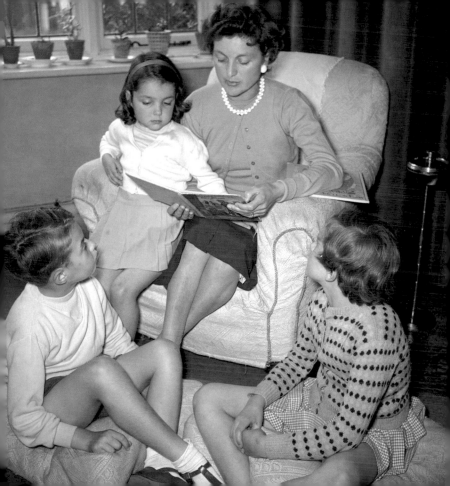

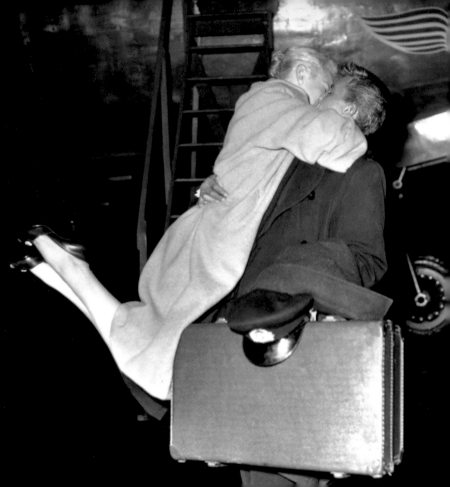

Absence makes the heart grow fonder.

Francis Davidson

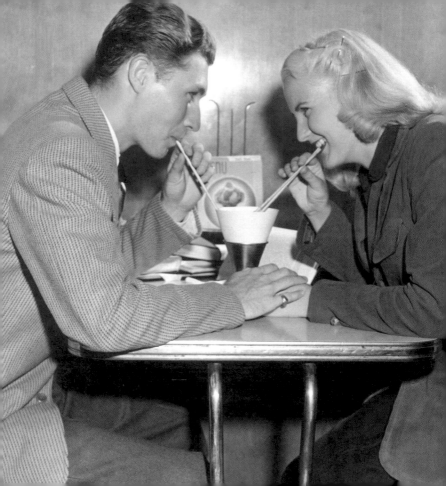

I can neither eat nor
drink for thinking of you
my dearest love, I never
touch even pudding.

Horatio Nelson

At the top of the stairs
I ask for her hand. OK.
She gives it to me.
How her fist fits my palm.
A bunch of consolation.
We take our time
Down the steep carpetway
As I wish silently
That the stairs were endless.

Adrian Mitchell

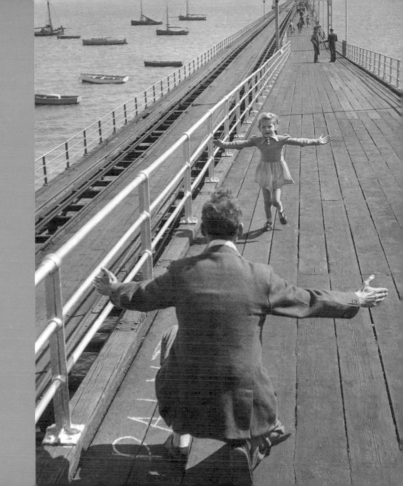

Some people say
there are plenty of
fish in the sea,
until you find
love—then there is
only one.

David Baird

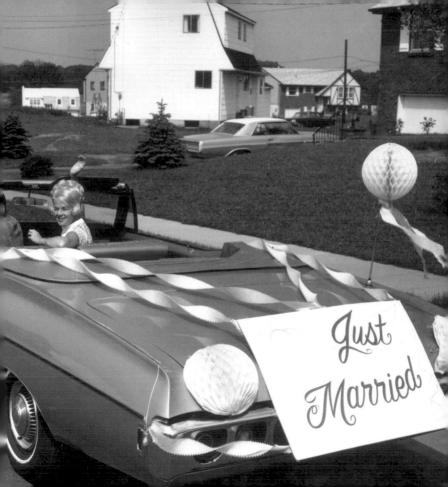

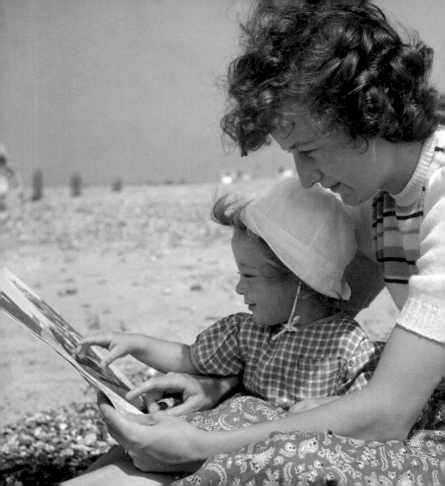

You may have tangible wealth untold;
Caskets of jewels and coffers of gold.
Richer than I you can never be—
I had a mother who read to me.

Strickland Gillilan

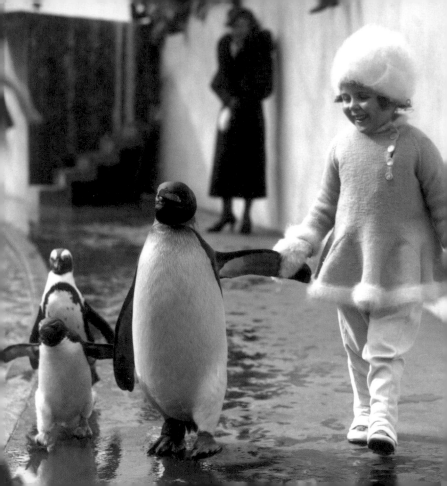

I don't go for fancy cars
For diamond rings
Or movie stars
I go for penguins
Oh Lord I go for penguins

Lyle Lovett

Daisy Daisy,
Give me your answer do!
I'm half crazy,
All for the love of you!
It won't be a stylish marriage,
I can't afford a carriage,
But you'll look sweet upon
 the seat
Of a bicycle built for two!

Harry Dacre

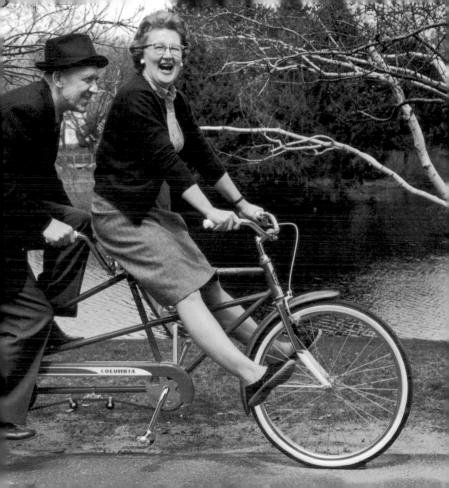

I will come back alive &
as deep in love with you
as a cormorant dives, as
an anemone grows, as
Neptune breathes, as the
sea is deep.

Dylan Thomas

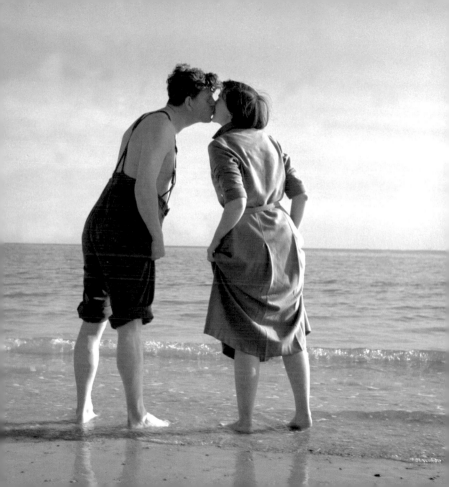

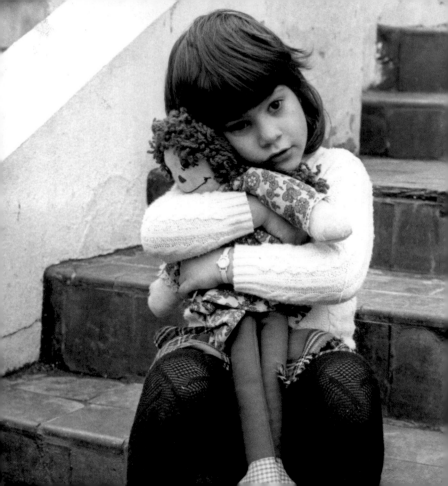

The way to love
anything is to
realize that it
might be lost.

G. K. Chesterton

All the breath and the bloom of
 the year in the bag of one bee:
All the wonder and wealth of the
 mine in the heart of one gem:
In the core of one pearl all the
 shade and the shine of the sea:
Breath and bloom, shade and
 shine,—wonder, wealth, and—
 how far above them—
Truth, that's brighter than gem,
Trust, that's purer than pearl—
Brightest truth, purest trust in the
 universe—
All were for me in the kiss of
 one girl.

Robert Browning

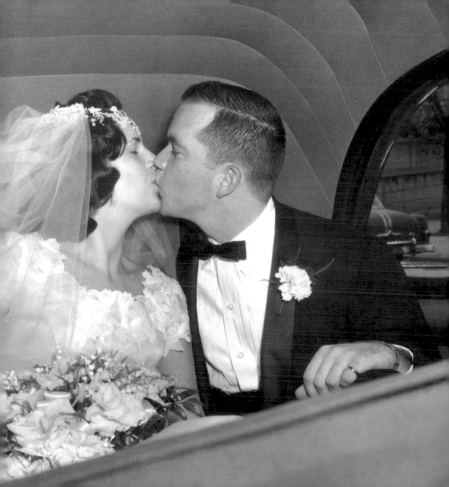

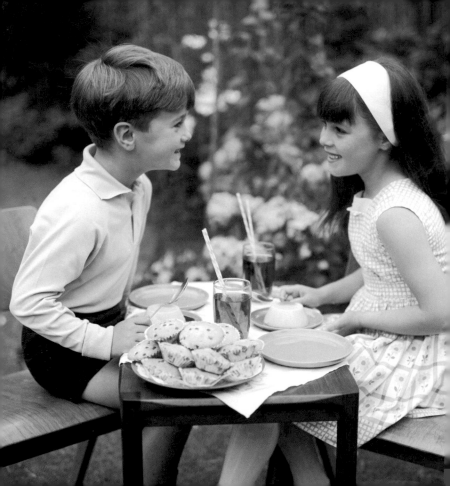

Picture you upon my knee,
Just tea for two and two for tea,
Just me for you and you for me alone.

Nobody near us to see us or hear us,
No friends or relations on weekend vacations.
We won't have it known, dear,
That we own a telephone, dear;

Day will break and you'll awake
And start to bake a sugar cake,
For me to take for all the boys to see.

We will raise a family,
A boy for you, a girl for me.
Oh, can't you see how happy we would be?

Irving Caesar

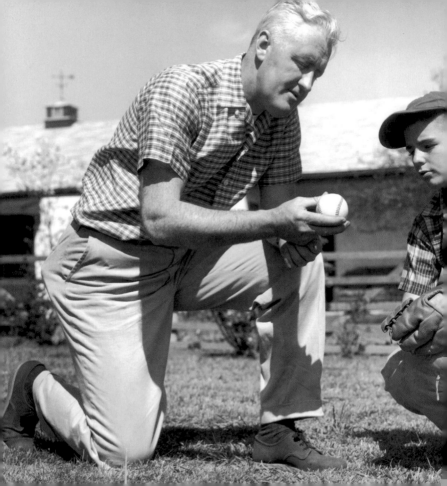

Perfect love sometimes
does not come until
the first grandchild.

Love is a
strange brooch

William Shakespeare

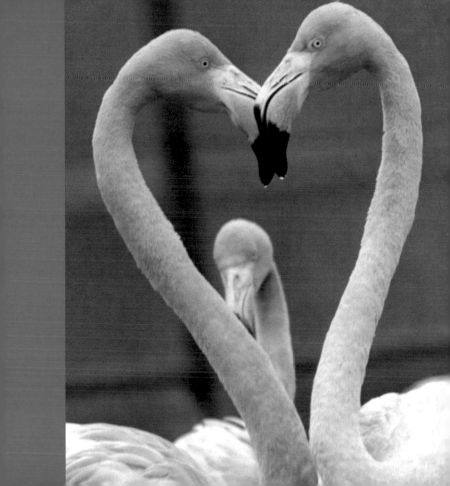

The Art of Love:
knowing how
to combine the
temperament of
a vampire with
the discretion of
an anemone.

E. M. Cioran

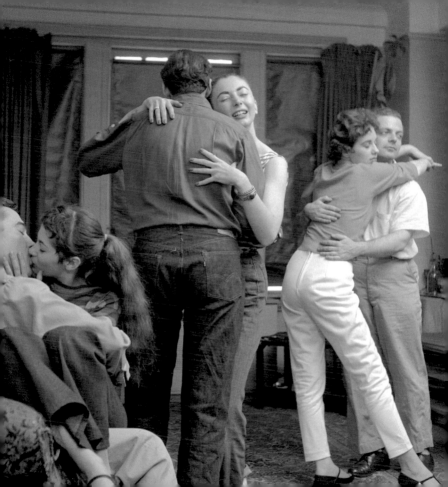

When our two souls stand up erect and strong,
Face to face, silent, drawing nigh and nigher,
Until the lengthening wings break into fire
At either curved point, - what bitter wrong
Can the earth do us, that we should not long
Be here contented? Think! In mounting higher,
The angels would press on us, and aspire
To drop some orb of golden song
Into our deep, dear silence. Let us stay
Rather on earth, Beloved – where the unfit
Contrarious moods of men recoil away
And isolate pure spirits, and permit
A place to stand and love in for a day,
With darkness and the death-hour rounding it.

<div align="right">Elizabeth Barrett Browning</div>

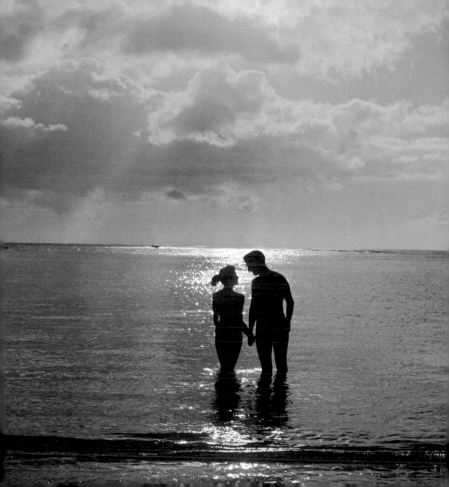

Love consists in this,
that two solitudes
protect and touch
and greet each other.

Rainer Maria Rilke

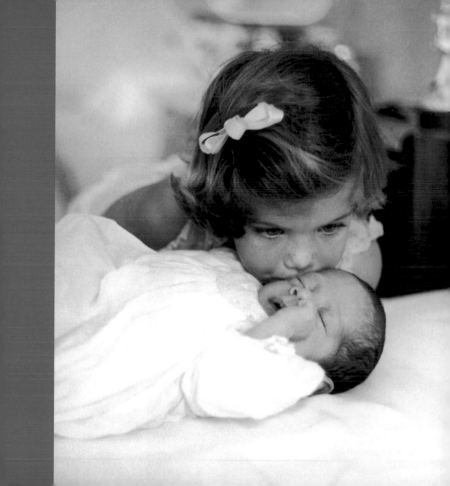

The summer wind, came blowin' in
 from across the sea
It lingered there to touch your hair
 and walk with me
All summer long we sang a song and
 then we strolled that golden sand.

Johnny Mercer

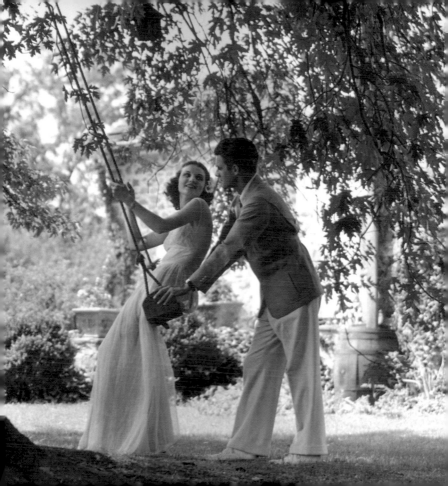

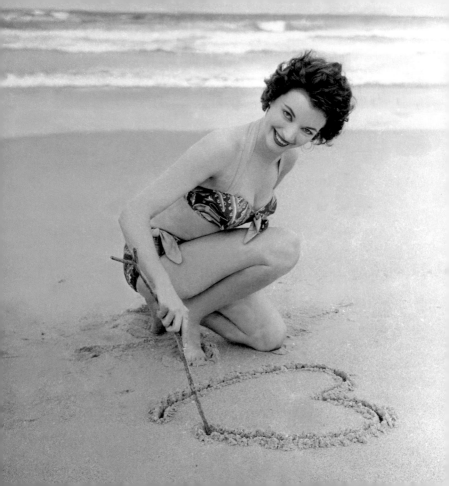

My true-love hath my heart,
and I have his...

Sir Philip Sidney

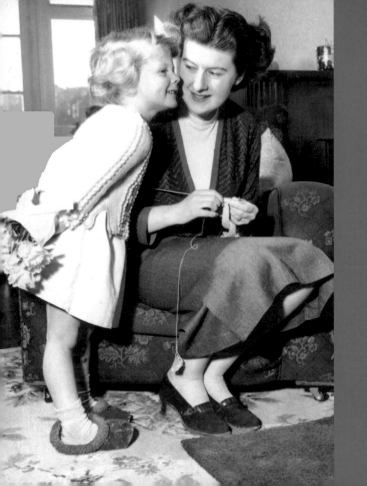

God could not be everywhere and therefore he made mothers.

Jewish proverb

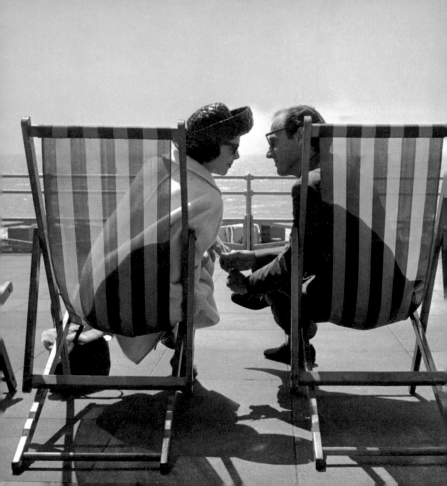

Oh, I do like to be
Beside the seaside,
I do like to be
Beside the sea,
I do like to stroll
Upon the Prom, Prom, Prom,
Where the brass bands play
Tiddely-om-pom-pom!

So just let me be
Beside the seaside,
I'll be beside myself with glee,
And there's lots of girls beside,
I should like to be beside
Beside the seaside!
Beside the sea!

Mark Sheridan

81

"Ronnie sort of grunted and said 'I say!' and I said 'Hullo?' and he said 'Will you marry me?' and I said 'All right,' and he said 'I ought to warn you, I despise all women,' and I said 'And I loathe all men' and he said 'Right-ho, I think we shall be very happy'"

P.G.Wodehouse

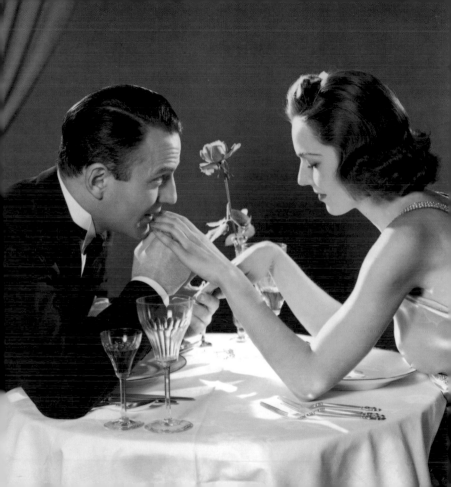

What tenderness and what devotion; what illimitable confidence; infinite revelations of inmost thoughts; what ecstatic present and romantic future; what bitter estrangements and what melting reconciliations; what scenes of wild recrimination, agitating explanations, passionate correspondence; what insane sensitiveness, and what frantic sensibility; what earthquakes of the heart and whirlwinds of the soul are confined in that simple phrase, a schoolboy's friendship!

Benjamin Disraeli

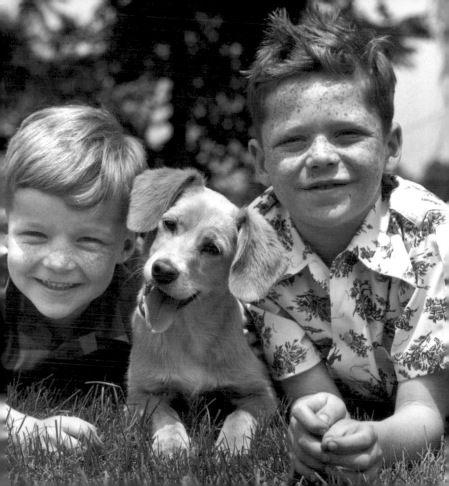

There is a courtesy of
the heart; it is allied to
love. From it springs
the purest courtesy in
the outward behavior.

Goethe

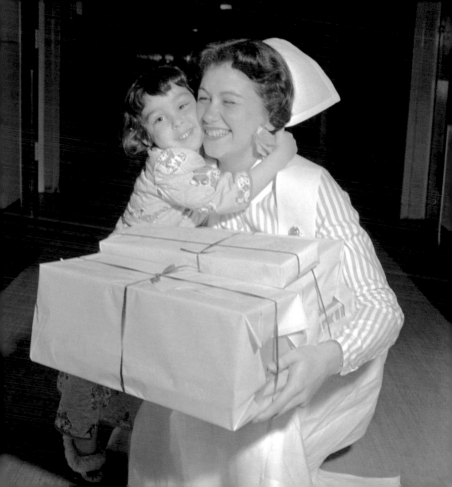

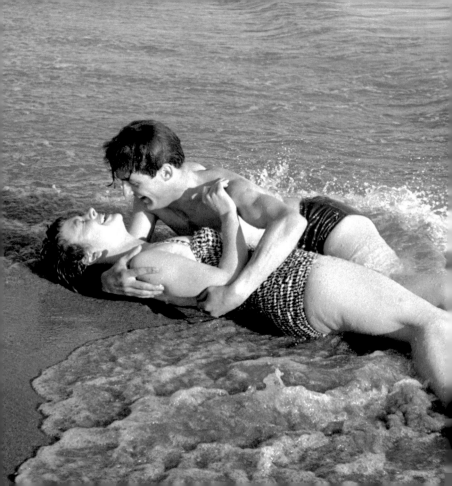

When Beauty and Beauty meet
 All naked, fair to fair,
The earth is crying-sweet,
 And scattering-bright the air,
Eddying, dizzying, closing round
 With soft and drunken laughter;
Veiling all that may befall
 After—after—

Rupert Brooke

Oh God... for two days,
I have been asking myself
every moment if such
happiness is not a dream.
It seems to me that what
I feel is not of earth.
I cannot yet comprehend
this cloudless heaven.

Victor Hugo

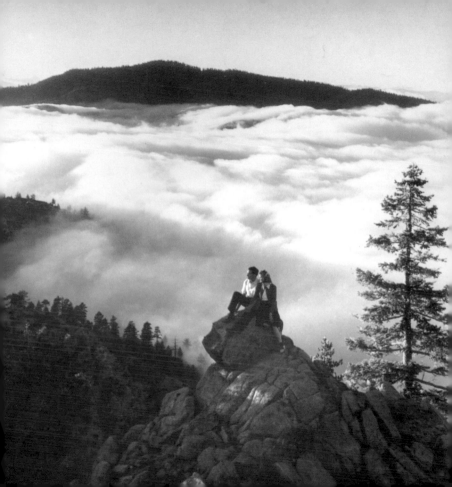

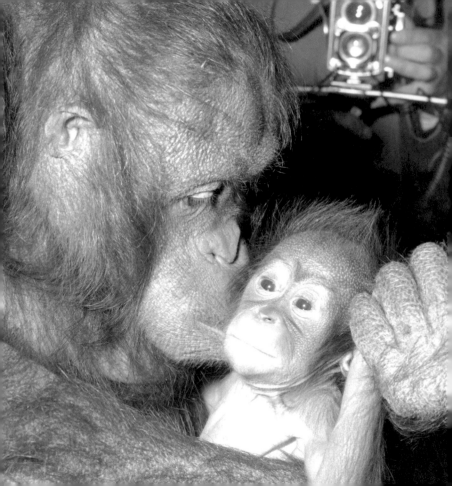

Mother is the name for God in the lips and hearts of little children.

William Makepeace Thackeray

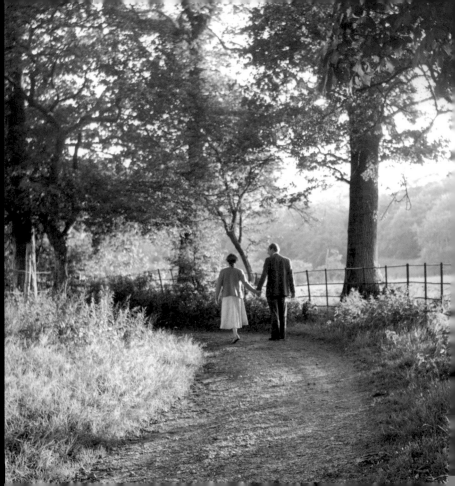

And therefore take the present time
 With a hey, and a ho, and a hey nonino;
For love is crowned with the prime
 In spring time, the only pretty ring time,
When birds do sing, hey ding a ding ding
 Sweet lovers love the spring.

William Shakespeare

Woe to the man whose heart has not learned while young to hope, to love— and to put its trust in life.

Joseph Conra

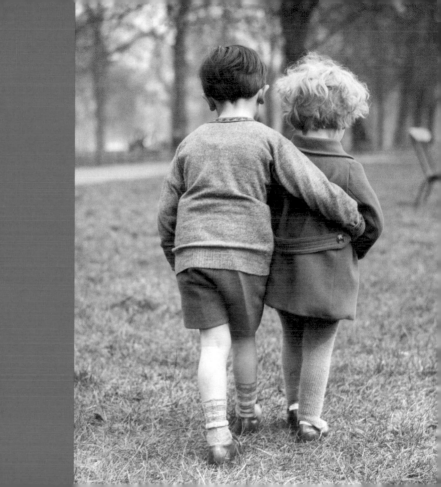

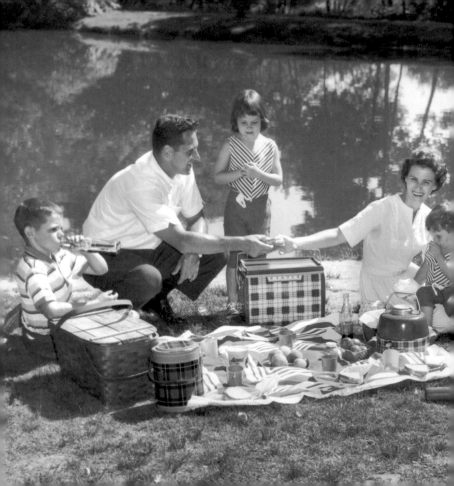

Spread love everywhere you go: first of all in your own home. Give love to your children, to a wife or husband, to a next door neighbor.

Mother Theresa

I like to get off with people,
I like to lie in their arms,
I like to be held and tightly kissed,
Safe from all alarms

I like to laugh and be happy
With a beautiful, beautiful kiss.
I tell you, in all the world,
There is no bliss like this.

Stevie Smith

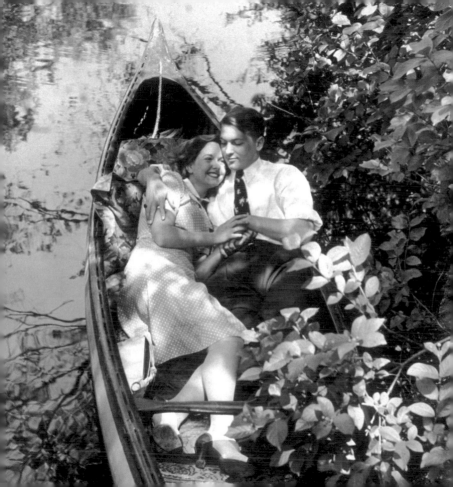

There is no
happy life
But in a wife

William Cavendish, Duke of Newcastle

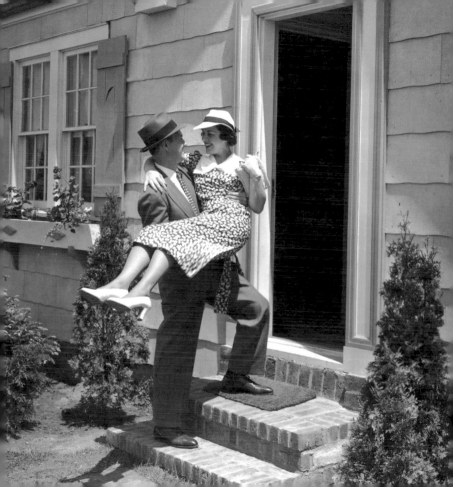

Of all animals kept for the recreation of mankind the horse is alone capable of exciting a passion that shall be absolutely hopeless.

Bret Harte

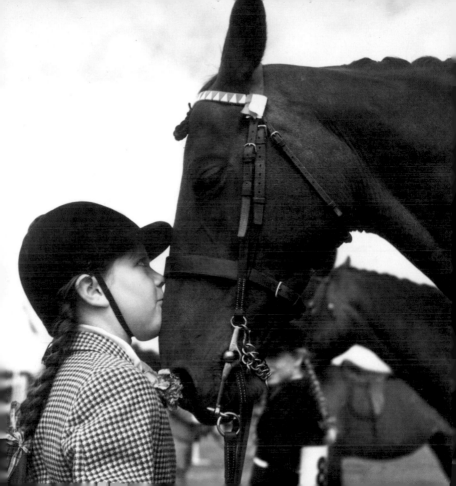

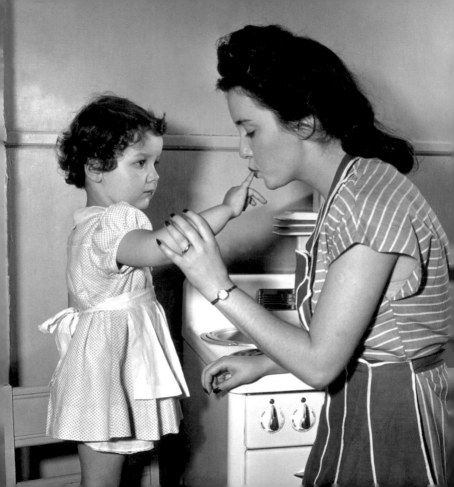

A mother is the truest friend we have, when trials, heavy and sudden, fall upon us; when adversity takes the place of prosperity; when friends who rejoice with us in our sunshine, desert us when troubles thicken around us, still will she cling to us, and endeavor by her kind precepts and counsels to dissipate the clouds of darkness, and cause peace to return to our hearts.

Washington Irving

Of the thousands and thousands of years
Time would take to prepare
They would not suffice
To entice
That small second of eternity
When you kissed me
When I kissed you
One morning in the light of winter
In Parc Montsouris in Paris
In Paris
On Earth
Earth that is a star

Jacques Prevert

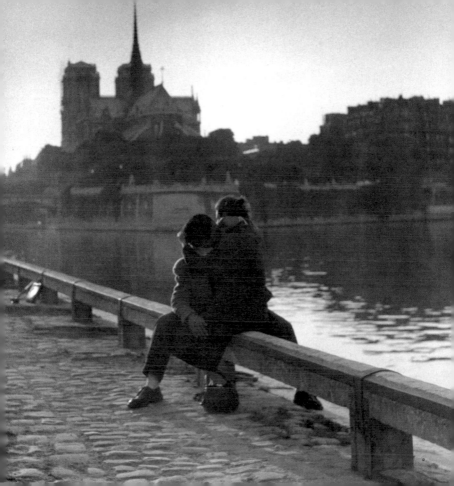

Picture Credits

All images Hulton Getty Picture Archive, unless otherwise stated.

Text Credits

AN INVITATION TO LOVE:

First English edition for North America
published by Barron's Educational Series, Inc., 2003.

First published by MQ Publications Limited
12 The Ivories, 6-8 Northampton Street, London, England

Design: Bet Ayer
Series Editor: Tracy Hopkins

All inquiries should be addressed to:
Barron's Educational Series, Inc.
250 Wireless Boulevard
Hauppauge, New York 11788
http://www.barronseduc.com

International Standard Book No. 0-7641-5633-0

Library of Congress Catalog Card No. 2002110109

Printed and bound in China

9 8 7 6 5 4 3 2 1

Cover image © Hulton Getty Picture Archive